Start *with* Art

Landscapes

© Aladdin Books Ltd 2000

Designed and produced by
Aladdin Books Ltd
28 Percy Street
London W1P 0LD

ISBN 0 7496 3765 X

First published in Great Britain
in 2000 by
Franklin Watts
96 Leonard Street
London EC2A 4XD

Project Editor
Sally Hewitt

Editor
Liz White

Designer
Flick Killerby

Illustrator
Catherine Ward - SGA

Picture Research
Brooks Krikler Research

Printed in Belgium
All rights reserved

Original Design Concept
David West Children's Books

A CIP catalogue entry for this book is available from the British Library.

The project editor, Sally Hewitt, is an experienced teacher. She writes and edits books for children on a wide variety of subjects including art, music, science and maths.

The author, Sue Lacey, is an experienced teacher of art. She currently teaches primary school children in the south of England. In her spare time, she paints and sculpts.

photocredits: Abbreviations: t-top, m-middle, b-bottom, r-right, l-left, c-centre
Cover m and pages 3, 7, 10, 13, 20, 26, back cover: Roger Vlitos; Cover b & pages 4b, 9, 11, 15, 17, 19, 21, 25, 29, 31: AKG London; 22: AKG. © ADAGP, Paris and DACS, London 2000; 27: AKG. © Salvador Dali - Foundation Gala - Salvador Dali / DACS 2000.

Start with Art
Landscapes

Sue Lacey

FRANKLIN WATTS
LONDON • SYDNEY

INTRODUCTION

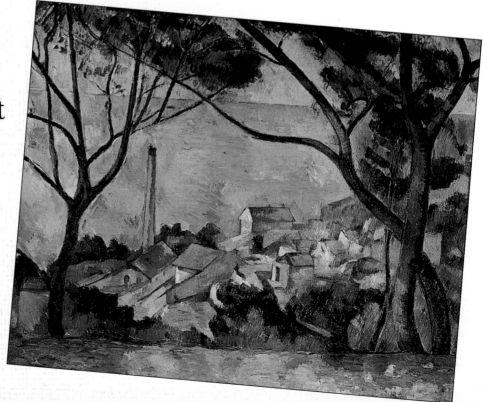

Artists work with many different tools and materials to make art. They also spend time looking carefully at patterns, shapes and colours around them.

This book is about how artists see **landscapes**. On every page you will find a work of art by a different famous artist, which will give you ideas and inspiration for the project.

You don't have to be a brilliant artist to do the projects. Look at each piece of art, learn about the artist and have fun being creative.

CONTENTS

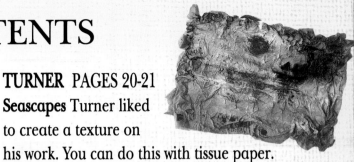

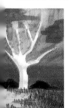
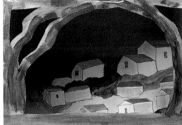
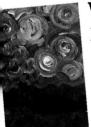

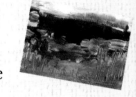
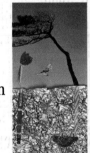

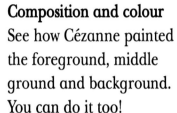

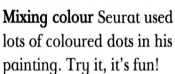

WORKING LIKE AN ARTIST

It can help you in your work if you start by looking carefully and collecting ideas, just like an artist. Artists usually carry a sketch book round with them all the time so they can get their ideas on paper straight away.

Words
You can write some words to remind you of the shapes, colours and patterns you see.

Materials
Try out different pencils, pens, paints, pastels, crayons and materials to see what they do. Which would be the best for this work?

Colour
When using colour, mix all the colours you want first and try them out. It is amazing how many different colours you can make.

Using a sketch book Before you start each project this is the place to do your sketches. Try out your tools and materials, mix colours and stick in some interesting papers and fabrics. You can then choose which you want to use.

Drawing landscapes

Learning to draw and paint landscapes can seem difficult. Here are some simple techniques which can help you to improve your skills.

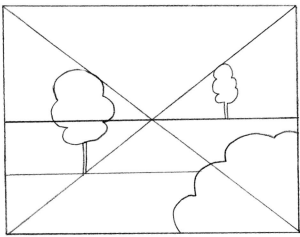

Composition

A landscape has a foreground, a middle ground and a background. Above is a simple grid that will help you with your composition.

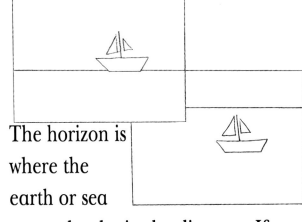

The horizon is where the earth or sea meets the sky in the distance. If you move the horizon line on a painting, you can make the same landscape or seascape look very different.

Be a magpie

Make a collection of things that are of interest to you like feathers, stones or materials. Anything that catches your eye could be useful in your artwork.

Art box You can collect tools and materials together for your work and put them in a box. Sometimes you may need to go to an art shop to buy exactly what you need. Often you can find things at home you can use. Ask for something for your art box for your birthday!

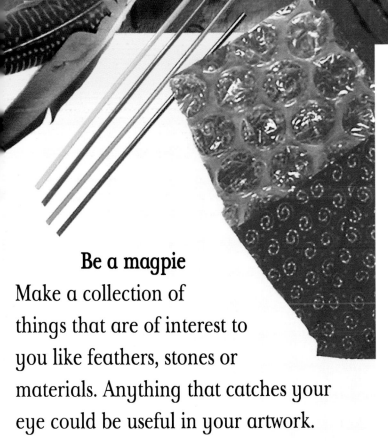

SEEING LIGHT

WHAT YOU NEED
Pencils • Paints
Paint Brush • Paper

Many of Monet's paintings show the same landscapes at different times of the day. Look at some trees near where you live and see how they change colour as the light changes. Make some sketches of the trees and paint them in Monet's colours.

PROJECT: PAINTING LIGHT

Step 1. Draw some trees near your home in your sketch book. Look carefully at the shape of the trunk, branches and leaves.

Step 2. Mix as many different blues and yellows as you can. Try them out in your sketch book. Paint the trees using the colours you have mixed. Make dabs, blobs and lines of colour next to each other. For white, let the white paper show through.

Step 3. Try painting the same trees at different times of the day and different times of the year like Monet, see how the colours change.

GALLERY

The Three Poplars, Autumn 1891
CLAUDE MONET (1840-1926)

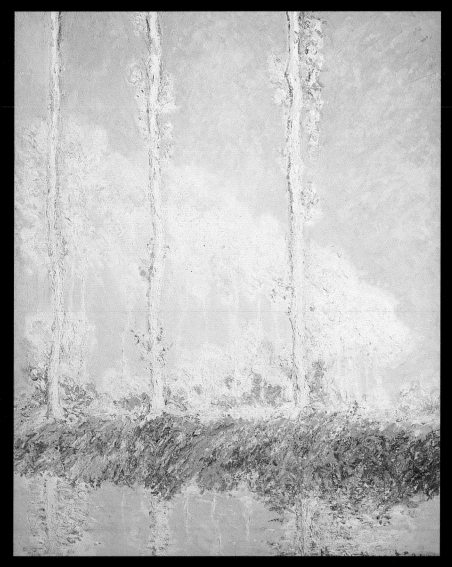

CONTRAST
The trees stand out against the sky because the blue, gold and pink contrast with each other.

SEASONS
This painting shows poplar trees in autumn. Monet painted the same trees in spring and summer.

DISTANCE
The trees and sky in the distance are very pale, this makes them look further away.

BRUSHSTROKES
Monet put dabs and lines of different colours near to each other. They give the painting texture.

Claude Monet had a hard time when he set out to become an artist. His family would not give him any money and his wife died when she was young. He worked outside using many colours to show how landscapes were altered by the ever-changing light. At first, nobody liked his pictures, but later people bought his paintings and he became rich.

COMPOSITION AND COLOUR

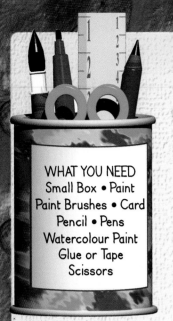

WHAT YOU NEED
Small Box • Paint
Paint Brushes • Card
Pencil • Pens
Watercolour Paint
Glue or Tape
Scissors

The way a picture is put together is called its composition. You can make the foreground and middle ground stand out from the background in a 3-D composition.

PROJECT: 3-D COMPOSITION

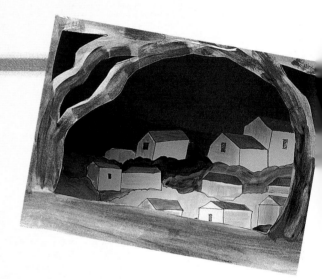

Step 1. Take a small box and paint a sea on the bottom and halfway up the inside. The rest can be the sky. Look at Cézanne's painting to help you with colours.

Step 3. Make a frame for the front of the box and draw and paint trees on it. Stick it to the front of the box. You now have a 3-D painting.

Step 2. You may need help with this. Take a piece of card slightly smaller than the front of the box. Draw some houses and trees in pencil. Fill in with watercolour paint and cut around the top edge. Fold the bottom under and glue or tape it into the box halfway in.

GALLERY

La Mer à L'Estaque 1883-1886
PAUL CÉZANNE (1839-1906)

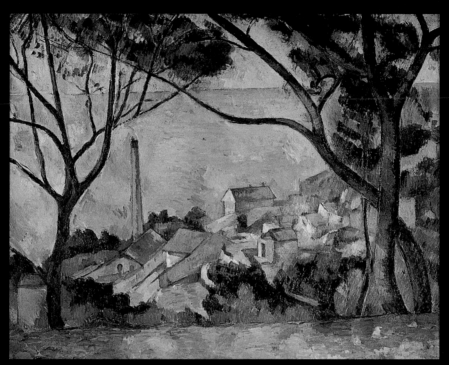

COMPOSITION
Can you see how the painting is divided into three? The foreground which is trees and land, the middle ground which is the houses and the sea and mountains in the background.

DISTANCE
The foreground shows the most detail. Paler colours have been used to paint the sky and mountains. It makes them seem further in the distance.

Paul Cézanne grew up in Southern France. He was a shy, awkward young man who longed to be a painter. After working for a while in his father's bank, Cézanne went to Paris to become an artist. Through copying the work of famous artists he taught himself to paint. Working outside was important to Cézanne and he made up a new way of painting using blocks of colour. Later he was called the "Father of Modern Art", because of his original style.

MOVEMENT

Vincent Van Gogh used very thick oil paint to bring his paintings to life. You can use acrylic paints, which dry more quickly. If you mix your paints very thickly, you can paint a sky with swirls of colour like Van Gogh's.

GALLERY

The Starry Night 1889
VINCENT VAN GOGH (1853-1890)

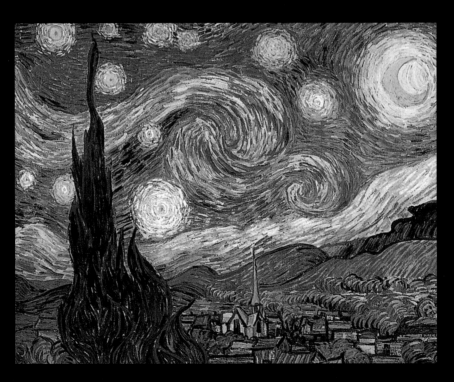

CONTRAST
The dark cypress tree stands out against the light of the stars in the evening sky.

SKIES
"I never get tired of looking at the blue sky," Van Gogh told his mother. Here he has painted a glowing night sky.

FEELING
Van Gogh put a great deal of feeling into his work. If you look closely you can see almost every line of paint.

PROJECT: MOVEMENT IN PAINTING

Step 1. On a piece of card, sketch the sky and some trees and plants on a starry, moonlit night. Don't forget the shadows.

Step 2. Mix some blues, purples, black, yellows and white. Make sure the paint is really thick. Start at the top of your sketch and paint the shapes with lines and swirls of blue, purple and yellow. A comb can be used to add texture.

During his life Vincent Van Gogh was poor, often hungry and ill – he was rejected by many people. The church did not want his help with the poor. Artists did not like his paintings. His brother Theo was the only person who believed in him. Van Gogh had very little money whilst he was alive, but after his death his paintings began to sell for thousands, or even millions, of pounds.

Step 3. When the paint has almost dried, add some circles and swirls of white and yellow for the stars and moon.

Mixing colour

Seurat used lots of coloured dots to build up a picture. With a used matchstick, experiment in your sketch book with little dots of acrylic paint. Try to make the sea, sky and land look different from each other through the colours.

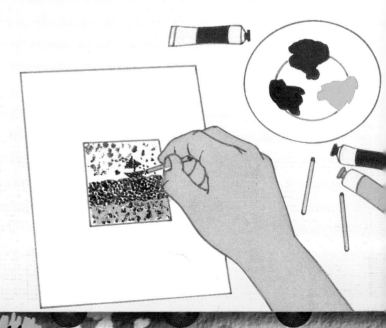

PROJECT: POINTILLISM

Step 1. Draw a simple sea scene in pencil. Don't make it too big!

Step 2. Put some red, yellow and blue acrylic paint on a paper plate. Make sure you have a different matchstick for each colour.

Step 3. Dip them into the paint and build up your picture using lots of coloured dots. If you want to make a green area you could mix blue dots and yellow dots. How do you think you could make an orange area?

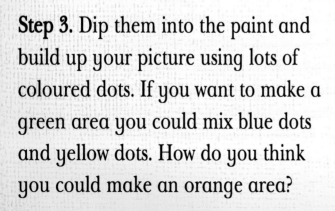

GALLERY

Port-en-Bessin 1888
GEORGES SEURAT (1859-1891)

OBSERVATION
Try using a magnifying glass to look at the colours.

FEELING
One of Seurat's aims was to give a great deal of feeling to his work. What do you feel when you look at this picture?

REPETITION
Seurat painted this French port over and over again. Each painting looks very different.

LIGHT AND SPACE
Seurat used pale coloured dots to give a sense of light and space.

Young Georges Seurat lived in Paris where his mother and uncle taught him to paint and draw. Seurat then decided to spend the rest of his life painting. He started a whole new way of working called "pointillism". He would put different coloured dots of paint next to each other to build up a whole picture. Many summers were spent by the sea painting the same view, especially at Port-en-Bessin.

COLOURS AND SHAPES

WHAT YOU NEED
Paint • Paint Brush
Card • Pencils
Scissors • Glue
Paper

Gauguin used bright colours and simple shapes in his paintings. Look at a small part of Gauguin's painting and examine the colours and shapes he used. You can make a wonderful collage using the same style.

PROJECT: ABSTRACT COLLAGE

Step 1. Make a viewfinder by folding a piece of paper into four. Cut out the middle and open it out. Put it over the part of Gauguin's painting (opposite) that you like the best.

Step 2. Paint some pieces of thin card with the colours you can see there. Leave them to dry.

Step 3. Lightly draw each shape in your viewfinder onto the right colour of card and cut them out.

Step 4. Place the pieces onto a larger piece of card. Glue them down when you are happy with the arrangement.

GALLERY

Matamoe 1892
PAUL GAUGUIN (1848-1903)

COLOUR
What mood do you think Gauguin was trying to show with the colours used in this painting?

SHAPE
Look at the way Gauguin has made the shapes in his picture very simple.

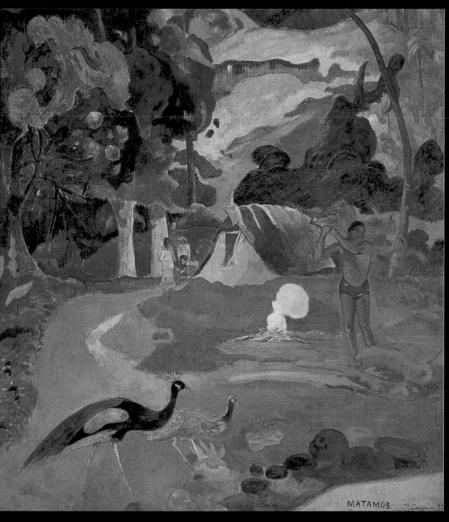

DETAIL
How many things can you see that have been painted in their exact colour?

Paul Gauguin led a colourful life like his many colourful paintings. He was very adventurous and loved to travel. Later in his life he left France to live on a South Sea island. He loved the bright, clear colours there and used them in his paintings. Gauguin thought that light, shape and colour were the most important part of paintings. You can see this in his work and in the moods that he creates in his paintings.

WEATHER AND SKIES

WHAT YOU NEED
Pastels • Paper
Hairspray

The sky often changes colour with the weather. Constable would sometimes use the skies in his paintings to reflect his mood. You could experiment with pastels and colours to create your own sky scene.

PROJECT: PASTEL SKIES

Step 1. Try out pastels in your sketch book to see how they work. Apply them in layers and use your fingers to smudge them, or allow the paper to show through. Spray the finished work with hairspray, to fix the pastels.

Step 2. Look out of a window, or sit outside at different times to make a number of sketches of the sky. Look for greys, yellows, reds, oranges and white, not just blue! Try to include some unusual features; sunsets, rainbows or storm clouds are interesting.

GALLERY

River Landscape c.1820
JOHN CONSTABLE (1776-1837)

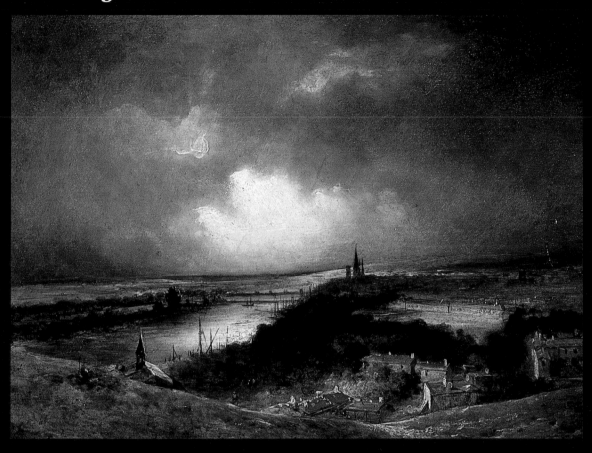

SKIES
Constable thought skies were one of the most important parts of his paintings.

SKETCHES
Constable made many sketches in charcoal or paint before he started a painting.

John Constable loved the English countryside, he spent most of his life there. He wanted to express his love of the countryside through his art. He would find a beautiful view and sit and sketch in charcoal and paint for hours. He loved to paint the clouds he saw as the weather changed.

SEASCAPES

Turner used white with oil to make his paint look almost transparent. He also liked to create a texture on the surface. If you use glue, tissue paper and paint, you can get a transparent, textured effect to your work.

PROJECT: MIXED MEDIA

Step 2. Mix up different yellow, red, orange and white colours for a sea picture. Use a big, soft brush to paint on top of the tissue paper making waves and swirls of water. Use lots of different colours like Turner. Let them blend into each other.

Step 1. Put a layer of glue onto some card. Crease and crumple some plain tissue paper and lay it onto the card. Paint more glue over the textured surface and leave it to dry.

GALLERY

The *Sun of Venice* Setting Sail 1843
J.M.W. TURNER (1775-1851)

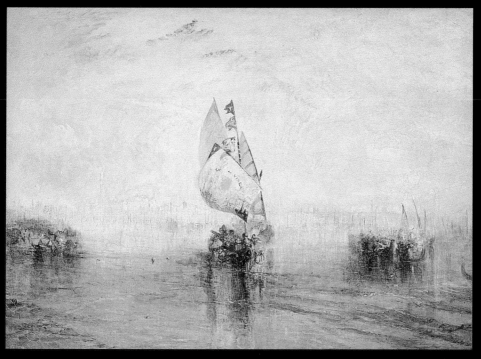

PALLET KNIFE
Instead of using a brush Turner used a small, flat knife to spread the oil paint on the canvas.

POETRY
This painting tells a sad story Turner read in a poem. It was about a fishing boat leaving Venice, never to return because of storms.

CONTRAST
The darker ripples of the sea contrast with the white and yellow sky.

The first drawings Turner did were put in the window of his father's barber shop in Covent Garden, London. At 14 he began to study art seriously and had his first picture in an art gallery when he was 17. As he travelled round England and Europe, he filled hundreds of sketch books with wonderful drawings and sketches, which he later turned into paintings.

SEEING SHAPES

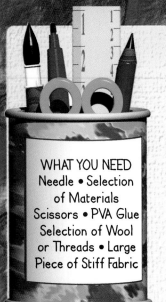

Kandinsky worked in paint. He used large areas of solid colour to make shapes. You can use the same ideas to make a textile landscape. Choose bright colours like the ones in the Murnau landscape, and glue and stitch them to some material.

GALLERY

Landscape with Church I 1909
WASSILY KANDINSKY (1866-1944)

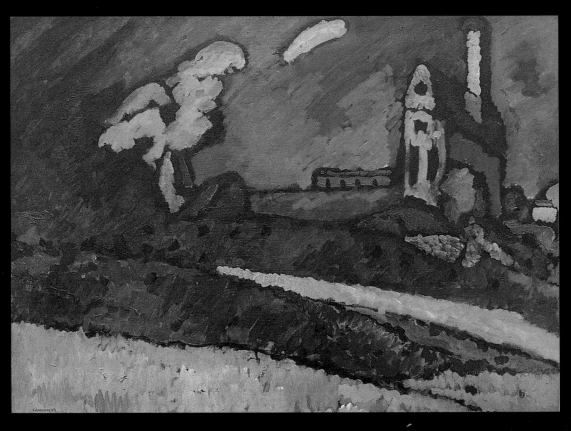

PROJECT: TEXTILES

Step 1. Collect some brightly coloured materials. You need a large piece of stiff fabric as a background. Cut out some shapes like the ones in Kandinsky's painting.

Step 2. Arrange your material onto the background to make a picture. Stick the pieces down using PVA glue. Once the glue has dried add some stitches to the materials in coloured wools or threads for small interesting features like stars, leaves or windows.

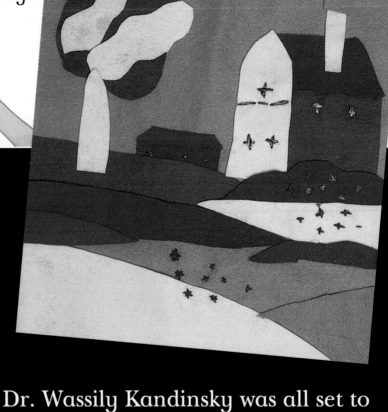

COLOUR
This landscape is painted in patches of bright colour. How many different colours can you see? Each colour plays an important part in creating an atmosphere or mood in this work of art.

FRIENDSHIP
Kandinsky did many paintings while he was staying at his friend's holiday house at Murnau.

FOCAL POINT
An important part of a painting that draws your eye, is called the focal point. What do you think is the focal point of this picture?

Dr. Wassily Kandinsky was all set to become a university professor in Russia when he decided he wanted to study art. He went on to paint in many different and exciting modern styles. He loved modern music and thought that as different sounds made a whole piece of music, so different colours and shapes can come together to make a painting.

LIGHT AND COLOUR

Renoir's painting has a sense of life and movement. A brush is not the only tool that can be used with paint. Artists often use their fingers and the end of their brushes to give texture and a feeling of movement.

PROJECT: FINGER PAINTING

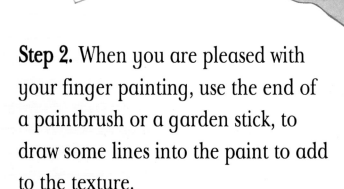

Step 1. Collect some coloured acrylic paints and put them onto a paper plate. Use your finger to spread the paint onto a piece of card. Wash your finger and dry it on a rag before using a fresh colour! Try using dabs and strokes to create water, sky and land.

Step 2. When you are pleased with your finger painting, use the end of a paintbrush or a garden stick, to draw some lines into the paint to add to the texture.

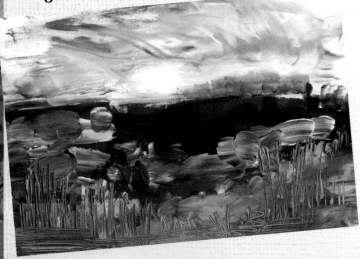

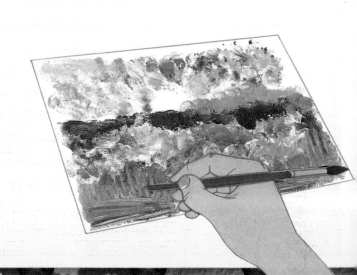

WHAT YOU NEED
Acrylic Paints
Paper Plate • Card
Paint Brush or
Garden Stick
Old Rag

GALLERY

The Seine at Champrosay 1876
PIERRE-AUGUSTE RENOIR (1841-1919)

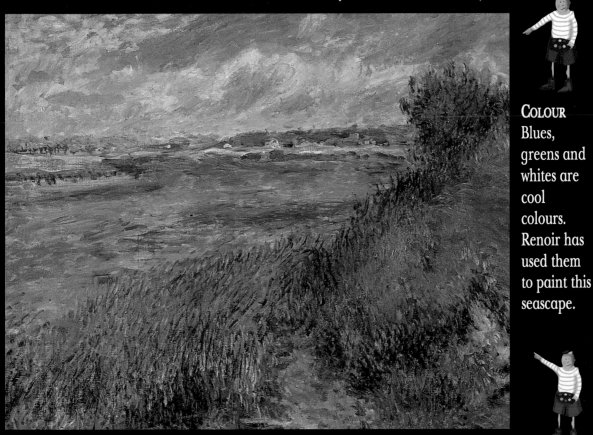

LIGHT
Renoir has chosen colours that make his painting full of light.

COLOUR
Blues, greens and whites are cool colours. Renoir has used them to paint this seascape.

HAPPINESS
How does this painting seem a happy and not a sad picture?

WINDSWEPT
The seaside is often windy. How has Renoir made the grass look windswept?

When he was 13, Auguste Renoir worked in a factory in France, painting flowers onto china cups and saucers. This was the start of his love of painting. Later, Monet became his friend, and together they sat outside painting the shimmering light on water, trees and hills. Renoir wanted every painting he did to be full of happiness.

SURREALISM

WHAT YOU NEED
Magazines
Scissors • Card
Tin Foil • PVA Glue
Blue Paint
Washing-up Liquid
Paint Brush

Salvador Dali put different objects together in a dream-like scene to make his art. This technique is called surrealism. You could cut out pictures from magazines and put them together to make some surrealist art.

PROJECT: SURREALIST SCENE

Step 1. Look through as many magazines as you can. Cut out some objects that interest you or make an interesting shape.

Step 2. Cover half a piece of card with crumpled tin foil and glue it on with PVA glue. Paint the tin foil with blue paint mixed with a drop of washing-up liquid. This will make it shimmer.

Step 3. Arrange your cut-out pictures to make a scene and its reflection.

GALLERY

Swans, Reflecting Elephants 1937
SALVADOR DALI (1904-1989)

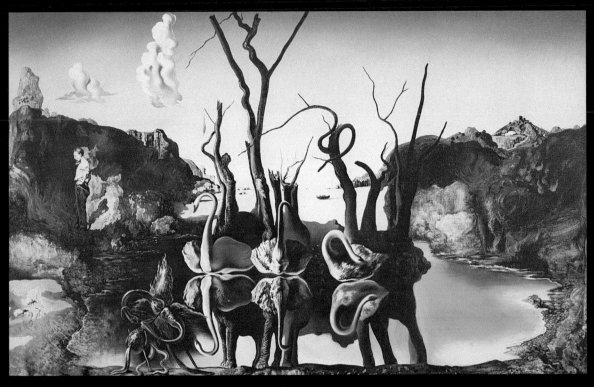

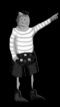

REAL LIFE
Do these clouds look like real or imagined clouds? Would you see a landscape like this in real life or in a dream?

WATER
Dali has painted the water in great detail to look still and smooth almost as though it was not real. The swans could be part of the trees or part of the water.

Many people thought the Spanish artist Salvador Dali was mad. His paintings were so full of unusual objects and ideas that they often seemed like an amazing or frightening dream. Yet Dali painted what he saw in his mind's eye, with great skill. He became one of the most famous artists in a group called surrealist painters.

JAPANESE ART

Hokusai used to paint, but he also used to make prints by carving a picture in wood and printing from it. You can draw a landscape in Hokusai's style and make a print from it using a flat piece of polystyrene called a press print sheet.

PROJECT: BRIDGE PRINT

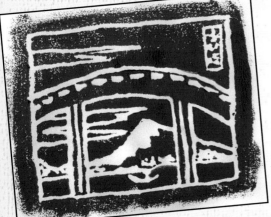

Step 1. Design a picture of a bridge going over a river or road.
Using a pencil draw it into the press print sheet.

Step 2. Cover the sheet with one colour of printing ink – blue or black would look good.
Press it onto a sheet of paper.
Carefully peel back the paper. Do several prints until you get the best one.

GALLERY

The Bridge in Fuji, c.1820
KATSUSHIKA HOKUSAI (1760-1849)

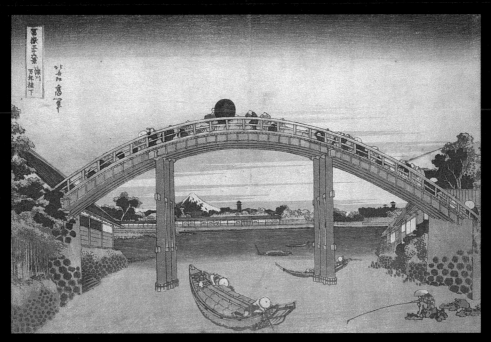

MOUNT FUJI
Can you see Mount Fuji in the distance?

LINES
Look at all the different lines in this print. They are very fine and crisp.

SHADOWS
Hokusai did not put shadows in his landscapes. This makes them look very flat and suitable for making a print.

SKYLINE
Most Japanese landscapes have a thin blue line for the sky.

One of Japan's most famous artists, Hokusai, started his career as an artist by making prints from blocks of wood. He was adopted by a family in Tokyo and they helped him to train as an artist. He painted, printed and illustrated books. He was particularly interested in bridges and did many bridge prints and paintings during his long life.

29

SKETCHING

WHAT YOU NEED
Charcoal • Paper
Rubber

Morisot would often sketch a landscape before painting it. She would look carefully at the scene first. Charcoal is good to use for sketching as it can smudge, it can be dark or light and a rubber can make interesting marks on it.

PROJECT: CHARCOAL SKETCH

Step 1. Choose a scene you would like to sketch. Try out some different marks you can make with the charcoal.

Step 2. Lightly draw in the outlines of the different shapes you see. Darken the areas that are in shadow and smudge the charcoal to make lighter shapes. Add details.

Step 3. If you want to lighten some areas, use a rubber to take away some charcoal and show the paper through.

GALLERY

In the Cornfield at Gennevilliers 1875
BERTHE MORISOT (1841-1895)

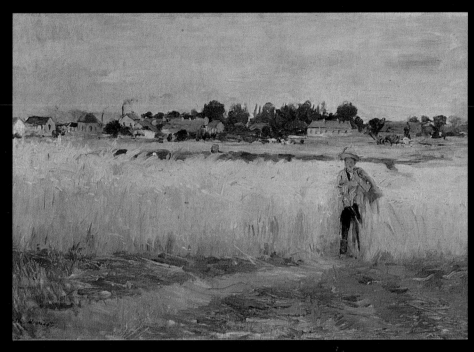

MOOD
Look at the colours Morisot uses. How do they make you feel?

LOOSE STYLE
Most of Morisot's work has a free and easy look to the way the paint is put on the canvas.

DIARY
Berthe's paintings were like a diary of good times spent with family and friends.

SKETCHES
Before painting Morisot would make pencil or charcoal sketches.

The first time Berthe Morisot had an art lesson was to help her draw a birthday card for her father. She went on to become an important member of the group of artists called French Impressionists. Berthe painted everyday scenes of her own family life, and spent a great deal of time with the artist Renoir when he painted outside.

GLOSSARY

COMPOSITION
The way different parts of a painting are arranged to get the effect the artist wants.

CONTRAST
Colours, shapes or patterns that look very different from each other when put side by side.

FOCAL POINT
The most important part of a painting that stands out from everything else and draws the eye to it.

FOREGROUND
The part of the view that is at the front of a picture.

OBSERVATION
Spending time looking carefully at the world around before making a work of art.

PALLET KNIFE
A trowel-shaped knife used to put paint on and to scrape it off the canvas.

POINTILLISM
Dots of paint put close to each other which the eye turns into blocks of colour.

SEASCAPE
A painting of a view of the sea.

SURREALISM
Art that brings together unusual objects and imaginary places that would not be seen in the real world.

TEXTURE
The feel or look of the outside or surface of something.

THREE-DIMENSIONAL
An object or work of art that stands out or that you can walk all around and look at from all sides.

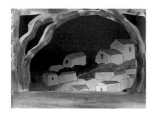

INDEX

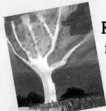